D0903850

AMOS WALKER'S DETROIT

AMOS WALKER'S

Text by **LOREN D. ESTLEMAN**

Photographs by **MONTE NAGLER**

DETROIT

A Painted Turtle book DETROIT, MICHIGAN

813.54
Est

© 2007 by Wayne State University Press, Detroit,
Michigan 48201.
All rights reserved.
No part of this book may be reproduced without
formal permission.
Manufactured in Canada.

11 10 09 08 07 5 4 3 2 1

Library of Congress Cataloging-in-Publication Data

Estleman, Loren D.
Amos Walker's Detroit / text by Loren D. Estleman ;
photographs by Monte Nagler.
p. cm.
ISBN-13: 978-0-8143-3357-0 (alk. paper)
ISBN-10: 0-8143-3357-5 (alk. paper)
1. Estleman, Loren D.—Quotations. 2. Estleman,
Loren D.—Settings—Pictorial works. 3. Walker,
Amos (Fictitious character)—Quotations, maxims,
etc. 4. Detroit (Mich.)—In literature. 5. Detroit
(Mich.)—Pictorial works. I. Nagler, Monte. II. Title.
PS3555.S84A6 2007
813'.54—dc22
2007009957

∞ The paper used in this publication meets the
minimum requirements of the American National
Standard for Information Sciences—Permanence of
Paper for Printed Library Materials, ANSI Z39.48-
1984.

Design by Chang Jae Lee
Typeset by Maya Rhodes
Composed in Zurich BT and Minion

9/08
BJU

CONTENTS

PREFACE

LOREN D. ESTLEMAN

AMOS WALKER'S DETROIT IS A PLACE WHERE THE RATIO of daylight to darkness is roughly equivalent to that in Anchorage, Alaska, in November. Complicated by cops, killers, duplicitous clients, sinister women, and his own untarnished ethic, his workdays and worknights bleed into each other so frequently that he seems to roll his boulder up and down Woodward Avenue through chronic twilight.

Detroit is noir city, as much as if not more so than New York or Los Angeles or the border towns festering on both sides of the Rio Grande—all of which have hosted some version of the fictional American private eye. It's older than any of them—factoring in the American Indian metropolis that greeted Cadillac—and its history, from Pontiac's Conspiracy beyond the "Murder City" era of the 1970s, has been one of intrigue and danger; yet until I wrote *Motor City Blue* in 1980, no writer of detective stories had seen fit to place a private detective against its backdrop.

It's a hard-boiled town, and the crumbling buildings and rusting railroad tracks of the warehouse district, the palaces across the limits in Grosse Pointe, and the black-hole shadows of the Cass Corridor were made to order for a remaindered knight chasing truth through a maze of threats, deceptions, and inconvenient corpses. City and protagonist are cut from the same coarse cloth. They are the series' two heroes. *Amos Walker's Detroit* asks Walker to take a step to the side and let his co-star take a step forward out of the dusk and into the light.

This is not a Chamber of Commerce project. Walker's descriptions are often critical, and there is a sardonic quality in even his gentlest assessments that would never be typeset in a tourist brochure. Make no mistake: He's fond of his hometown (he grew up in the city, although he was born in a hamlet some forty miles west), and would live or work in no other, but to be blind to its faults would not serve to its betterment. He's just as tough on himself ("I'd remembered to take my magic stupid pill that morning"), which I believe is

an important factor in his longevity; no one likes a braggart, and the darkly humorous nature of his self-effacement and outward-aimed barbs prevents any appearance of depression or bad temper. His observations from the windows of his tiny bungalow on the fringe of Hamtramck and his charmless office in an archaic building downtown present a more honest analysis of his community than appears four times a day on the TV news, broadcast from local facilities safely tucked away in the suburbs. When the anchors sign off, they commute home to Birmingham and Southfield and Farmington Hills; when Walker turns in, he does so in Detroit, and awakens there in the morning—or, as seems more usually the case, in the middle of the night.

Sometimes, of course, he awakens on his back on some hard surface. Whether it's the ceramic terrace of a swimming pool in West Bloomfield or a reeking patch of asphalt behind a blind pig on Erskine, the realization isn't likely to make any difference to the bump on his head. In Amos Walker's Detroit, the shortest distance between snarky conversation in the Hilton Garden Inn and a cracked skull in Bricktown is a crooked line. I've shot him in three places, two of them in Wayne County, and jailed him there and in the quasimythical Iroquois Heights, which packs all of Detroit's worst qualities into a tight sphere as hard and heavy as a wrecking ball. I'm a rough old cob of a god; however, I try to provide compensation with a successful solution to every case, and every once in a while a romantic assignation, occasionally with a woman who's honest.

When I began the series, area residents insisted I'd never find an audience outside the region. But readers embraced it throughout North and South America, in Europe, Australia, and Japan, and I found an unexpected support group in reviewers who were former Detroiters. They and their colleagues celebrated the freshness of a setting outside the smoothworn environs of the Atlantic seaboard and the West Coast. The city is both new and old territory to most readers, who either fear it or are fascinated by it based upon how it's

being represented in the media, and they enjoy the walking-tour-by-proxy down streets with exotic names like Dequindre and Beaubien. Most of them would never entertain the prospect of a visit to a noisy, dirty factory in their own zip code, yet they thrill to the smoke and din of the Ford River Rouge plant as described by Walker.

But words, no matter how carefully chosen and arranged on paper, cannot capture the changing colors of the Renaissance Center towers when the sky shifts from gray to blue to orange to gloss black, or the beldam dignity of the Wayne County Building, columned and cupolaed and quadrigaed with all the fusty flourish that a leaky early twentieth-century treasury could manage. And so I thank heaven for Monte Nagler.

Time and again, changing his lenses and blending his chemicals in his tidy studio in Farmington Hills or a goatherd's hut in South America—but most frequently in Detroit and its ever-metastasizing metropolitan area—Monte reproduces on photo stock what I try to illuminate on the pulp page. His work on this project began where mine ended, when he slipped into a pair of gumshoes and set out along mean streets in quest of landmarks and less prepossessing features I'd been writing about for more than a quarter-century—a number of which, such as Walker's house and seedy office, previously existed only in my imagination. His reputation opened doors that are closed to most, but how he managed access to my skull remains—well, a mystery.

Through the wizardry of creative processing, Monte gilds the ghetto, strips the manses of their glamour, then reverses the magic to show them as they really are. How hard and how many times I've tried to do the same thing in my writing. He belongs to that parabolic pantheon of great artists and innovators associated with Detroit, from Henry Ford to Diego Rivera, Joyce Carol Oates to Martha Reeves. This book is as much about Monte Nagler's Detroit as it is about Amos Walker's and mine. We're all lucky to have him.

ACKNOWLEDGMENTS

IT'S MY HAPPY DUTY TO EXPRESS MY DEEP APPRECIATION TO Acquisitions Manager Kathryn Wildfong and Director Jane Hoehner of Wayne State University Press and their staff for the enthusiasm and expertise they've brought to *Amos Walker's Detroit* since its conception, and to Dominick Abel, my agent, for ironing out the details on behalf on Monte Nagler and myself. Finally but foremost, I'm eternally grateful to the Detroit metropolitan area and its population for providing me with an endlessly fascinating subject, and to the area police, fire, and emergency personnel whose daily tours are more heroic than any thriller.

Loren D. Estleman

AMOS WALKER'S DETROIT

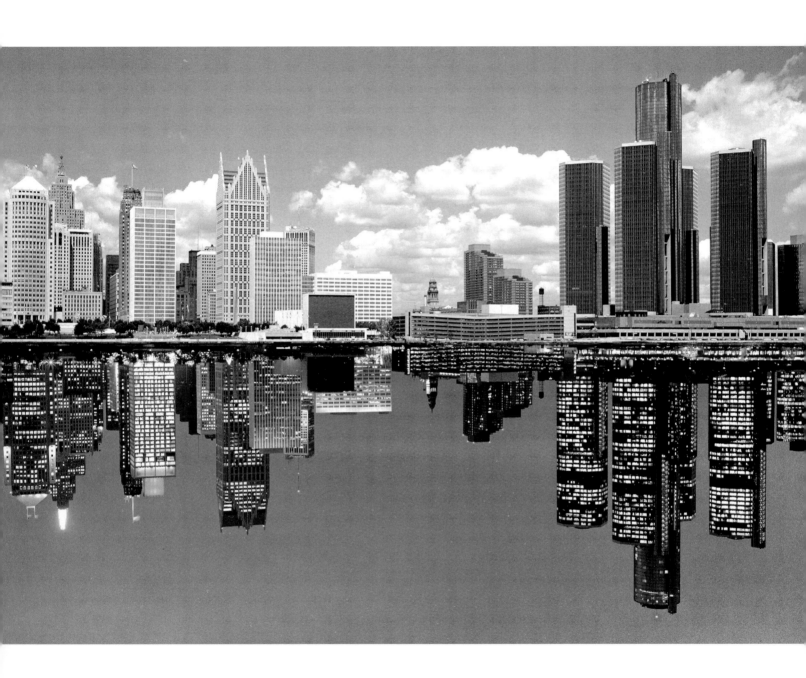

THE DETROIT SKYLINE

A FAMOUS CALENDAR SHOT OF THE DETROIT SKYLINE shows the daytime scape reflected on the surface of the river at night, gray granite and blue sky above, black onyx and lighted windows below. As I drove away from Most Holy Trinity, the picture rotated on its axis, nightside up. Half of the city was going home from work and the other half was going to work from home, signing out squad cars with engines still warm from the eight-to-four and grasping the handles of drill presses still slick from the sweaty palms that had operated them by daylight. Every day the two half-worlds pass each other on the Walter P. Chrysler and John Lodge and the Edsel Ford freeways with only a narrow median separating them. I was the only one who belonged to both.

Poison Blonde (2003)

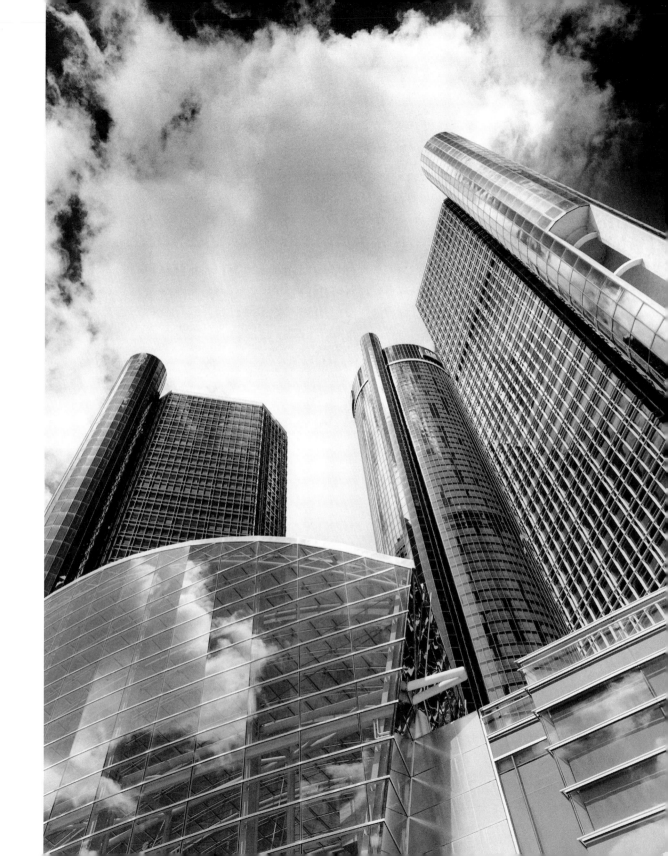

THE RENAISSANCE CENTER

THE BROWN-AND-SILVER TOWERS OF THE RENAISSANCE CENTER rose from the construction surrounding them like feudal ruins, afternoon sun striping the 740-foot central turret of the Detroit Plaza, the world's tallest failing hotel. Near that site in the year 1701, Cadillac erected a village of stout logs designed to withstand an Indian siege, and in 1974 history swung full circle when the city he had founded began to work on a structure impressive enough to discourage rioters and second-story men. The result is a Xanadu overlooking some of the poorest real estate in the Northwest Territory. The hotel received its baptism of blood shortly before it opened, when a young woman hurled herself from its summit. It was a bad omen. But while the hotel languishes because the city has no tourist trade, the office complex and shopping center prosper, those who can afford the rates flocking to the security of the Center's glass walls like fugitives from Poe's Red Death.... It's a pretty piece of work, and about as necessary as a Tiffany lamp in a home for the blind.

Angel Eyes (1981)

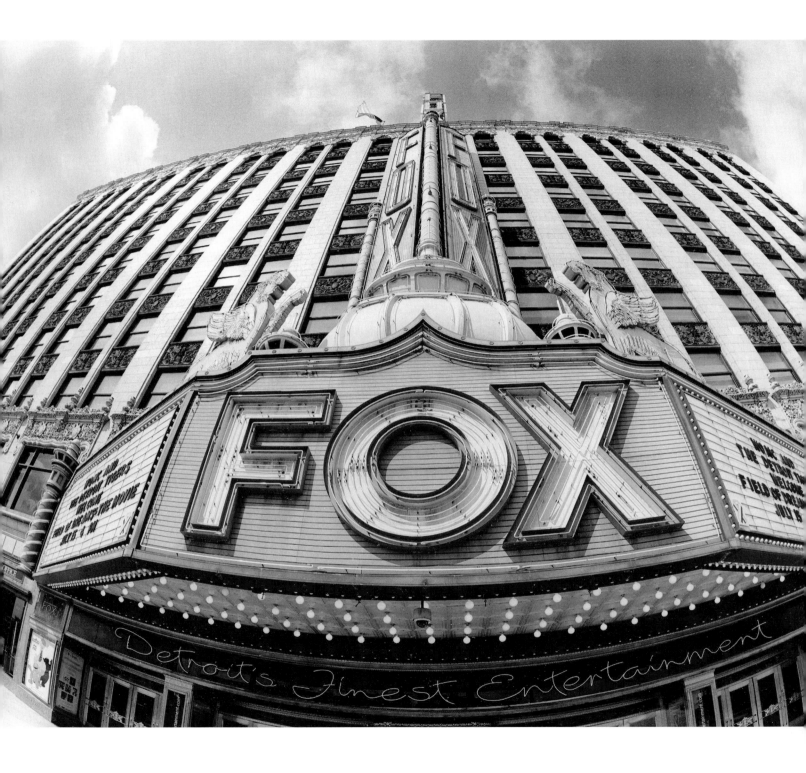

THE FOX THEATER

THERE IS ABOUT THE FOX AUDITORIUM A HEART-SICKENING enormity, dwarfing its best features and reducing the lone visitor to the status of a beetle plodding across a golden bowl. The trumpeting elephant's head mounted above the proscenium measures twenty feet from eartip to flaring eartip, but in the cavernous proportions of the room it looks as if a man of ordinary size could span it with arms outstretched. The electrified stained-glass globe hanging from the Arab tent of the ceiling, fashioned after a Fabergé egg, appears no larger than a beach ball, yet my entire living room could fit inside it, with space for a big-screen TV as well. It weighs two tons. The false arched balcony-boxes that march around the room's upper level might have sheltered the fierce-looking oversized saints of a medieval cathedral, and a gathering of one thousand people in the orchestra and balcony would leave four-fifths of the seats empty.

Never Street (1997)

WOODWARD AVENUE

DRY, GRAINY SNOW—THE KIND THAT USUALLY FALLS IN THE CITY— heaped the sills of unused doorways and lined the gutters in narrow ribbons, where the wind caught and swept it winding like white snakes across the pavement, picking up crumbles of muddy newspaper and old election campaign leaflets and empty condom wrappers and broken Styrofoam cups as it went, rattling them against the pitted sides of abandoned cars shunted up to the curb; weathering the corners off ancient buildings with bright-colored signs advertising various hetero- and homosexual entertainments; banging loose boards nailed over the windows of gutted stores defiled with skulls and crossbones and spray-painted graffiti identifying them as street-gang hangouts, Keep Out; buckling a billboard atop a brownstone two blocks south upon which a gaggle of grinning citizens gathered at the base of the Renaissance Center, near where its first suicide landed, urged me in letters a foot high to Take Another Look at Detroit. The air was as bitter as a stiffed hooker and smelled of auto exhaust.

Motor City Blue (1980)

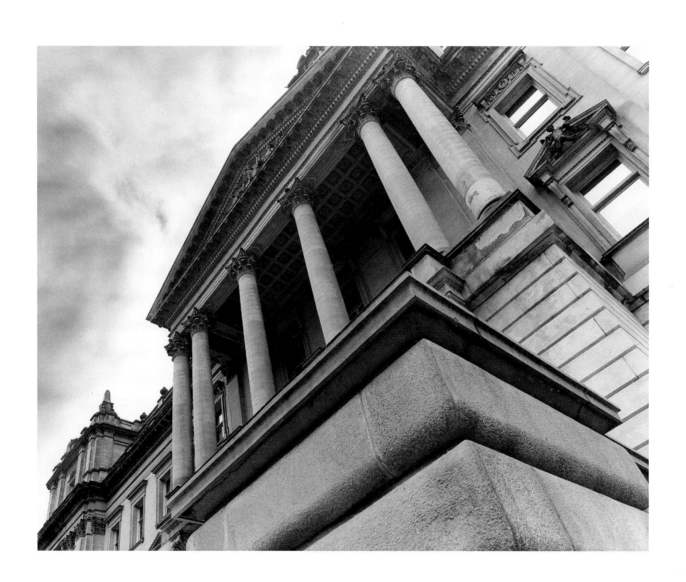

THE WAYNE COUNTY BUILDING

. . . Far down, dwarfed by the glass towers surrounding it, the cupola of the old county building stood lifting her ruffled skirts clear of the asphalt and concrete.

"The old lady of Randolph Street," Rooney said, thrusting his hands deep in his trouser pockets. "When I was with the circuit court I kept my office there after everyone else had moved into the City-County Building. They didn't care about cost when she was built. You can bet some public servant squeezed himself a tidy little retirement out of the overrun. It was worth it. This less-is-more crap has got out of hand. Stand an ice cube tray on end and call it architecture."

Every Brilliant Eye (1986)

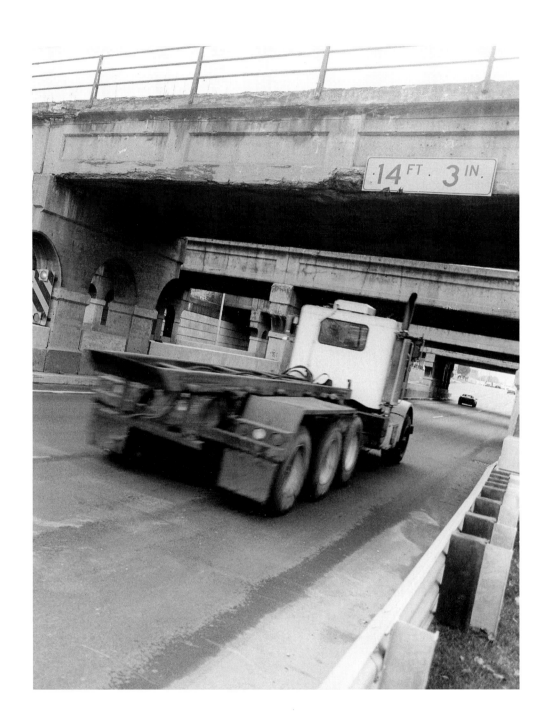

CITY TRAFFIC

WHEN THEY WERE STUMPED IN ANCIENT GREECE, THEY WENT to the oracle of Delphi. At Lourdes they take the waters, and I suppose in Akron they go down and watch tires being made. In Detroit, where we put the world on wheels or did anyway until the Japanese and Yugoslavs and the Brits rolled in, when our brains slip into neutral we lay rubber on the road and hit the gas.

Sweet Women Lie (1990)

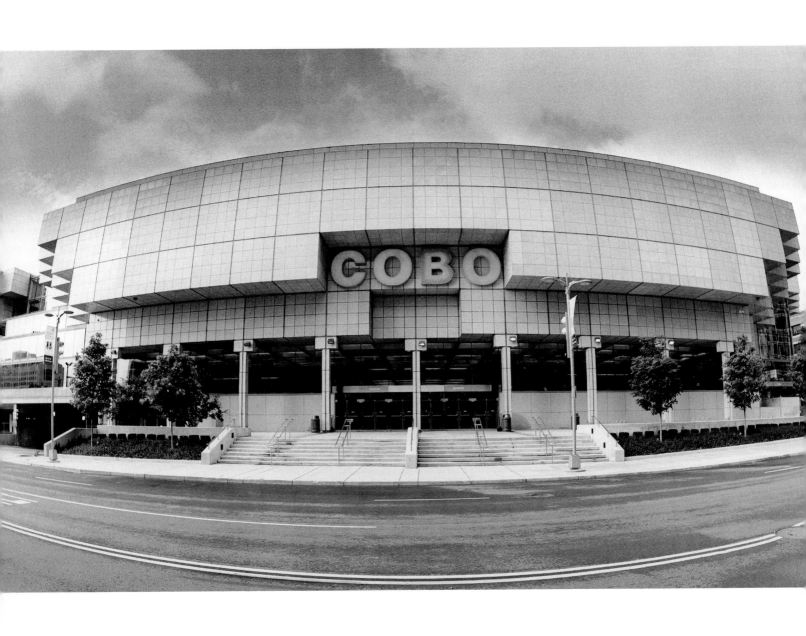

COBO HALL

WHERE HE WAS WAS COBO HALL, THREE HUNDRED THOUSAND square feet of convention arena. Exhibition space and concert facilities on the western end of the Detroit Civic Center, a white marble aircraft carrier of a building with a green granite section tacked on forty years ago and a curving covered promenade that looked like a furnace pipe with windows. Some history had taken place there, including the Republican National Convention of 1980, several decades of auto shows, and a couple of hundred body slams courtesy of the World Wrestling Federation. The incoming traffic plunged straight under the building by way of the John Lodge Expressway and parked on the roof, where the windshields shattered by homegrown vandals and tape-deck thieves tinkled down like fairy dust.

Poison Blonde (2003)

THE DETROIT INSTITUTE OF ARTS

A SCHIZOPHRENIC STRUCTURE, THE DETROIT INSTITUTE OF ARTS, with an arched Italian Renaissance central portion carved from white marble in 1927 and essentially blank gray granite wings stuck on the back forty-four years later.

Lady Yesterday (1987)

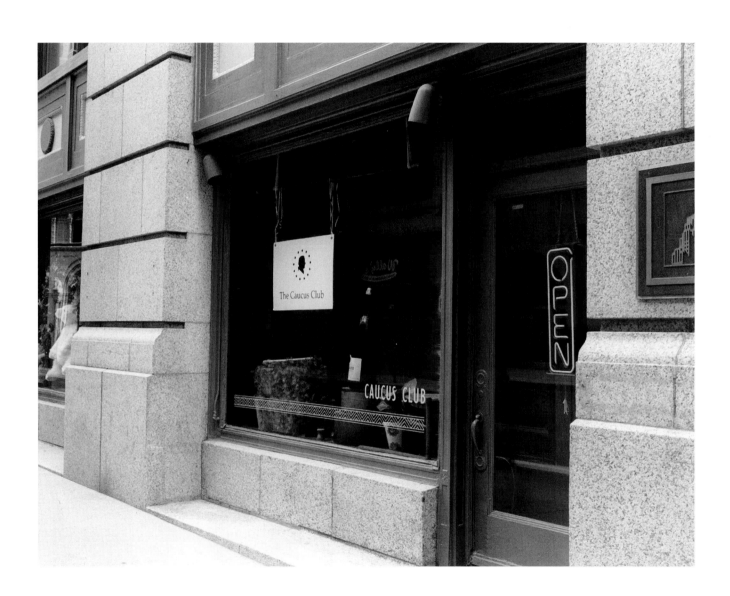

THE CAUCUS CLUB

THE BEVELED-GLASS DOOR OF THE DOWNTOWN CAUCUS CLUB opened before noon and drifted shut against the pressure of the closer, the way things move in dreams and deep water. While that was happening, Louise Starr stood in the electroplated rectangle of light wearing a white linen jumpsuit with matching unstructured jacket and a woven-leather bag on one shoulder. She had kept her pale-gold hair long, against the helmeted utilitarian fashion; in another six months most of the women who glanced up from their menus and kept on looking would be wearing theirs the same way.

A Smile on the Face of the Tiger (2000)

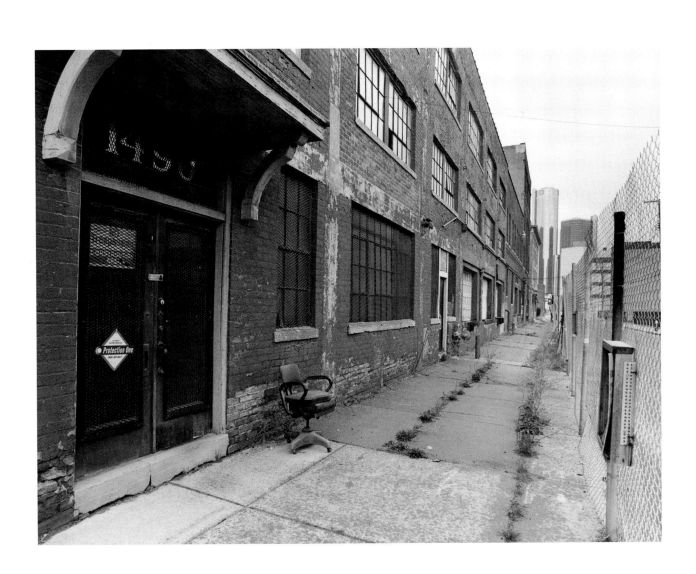

THE WAREHOUSE DISTRICT

IT'S SHRINKING FASTER THAN THE BRAZILIAN RAIN FOREST, this homely stretch of riverfront with its acres of crumbling warehouses, tangled miles of narrow-gauge track, and columns of cold smokestacks. Bricktown bulldozers are snorting in from the west and Rivertown backhoes are scooping out basements from the east, busy making the neighborhood safe for knickknack collectors, penthouse playboys, and blackjack dealers. The landscape is as bleak and hostile as they get, full of gaunt shells with empty windowpanes like missing teeth, and inside them rats and termites, but while they stand it's still possible for anyone who cares to go down and see the exposed living organs of an American industrial city. I don't imagine there are many who do.

Poison Blonde (2003)

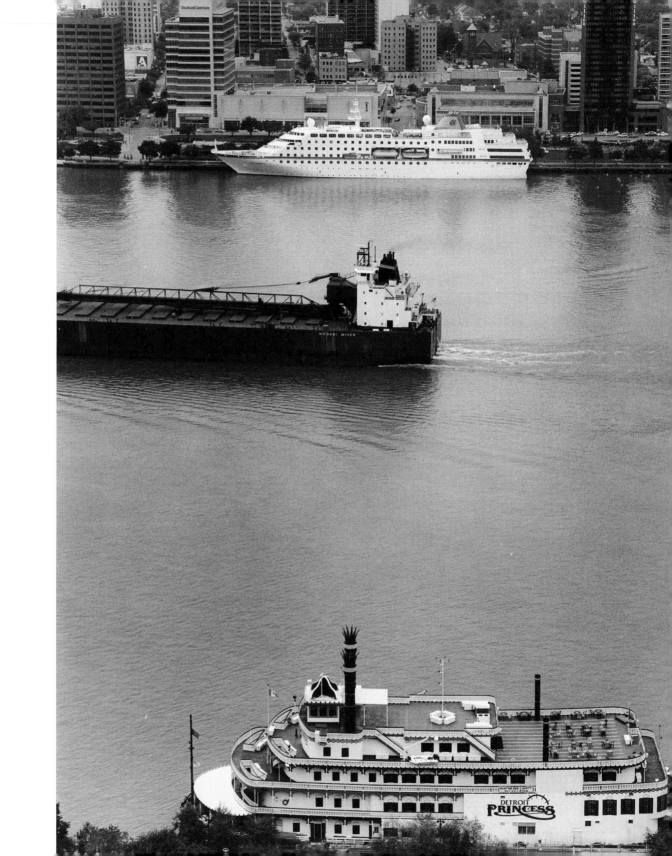

THE DETROIT RIVER

FOR THREE HUNDRED YEARS, THE BROAD, FLAT, SLUGGISH ARTERY men call the Detroit River has brought life to the community that flourishes, more or less, at its base. . . .

The river has brought death too. During the siege of Detroit, Pontiac, a great chief and not a bad automobile, turned a successful ambush of British reinforcements into a powerful psychological weapon when he sent logs floating past the fort at irregular intervals with the mutilated corpses of soldiers strapped to them in 1763. . . . And there's no telling how many wops and sheenies are sleeping the long sleep down there wrapped in concrete. . . .

An ore carrier wallowing beneath fifteen or twenty tons of iron pellets was crawling through the rust-colored waters at the mouth of the River Rouge on its way to the Ford plant.

Motor City Blue (1980)

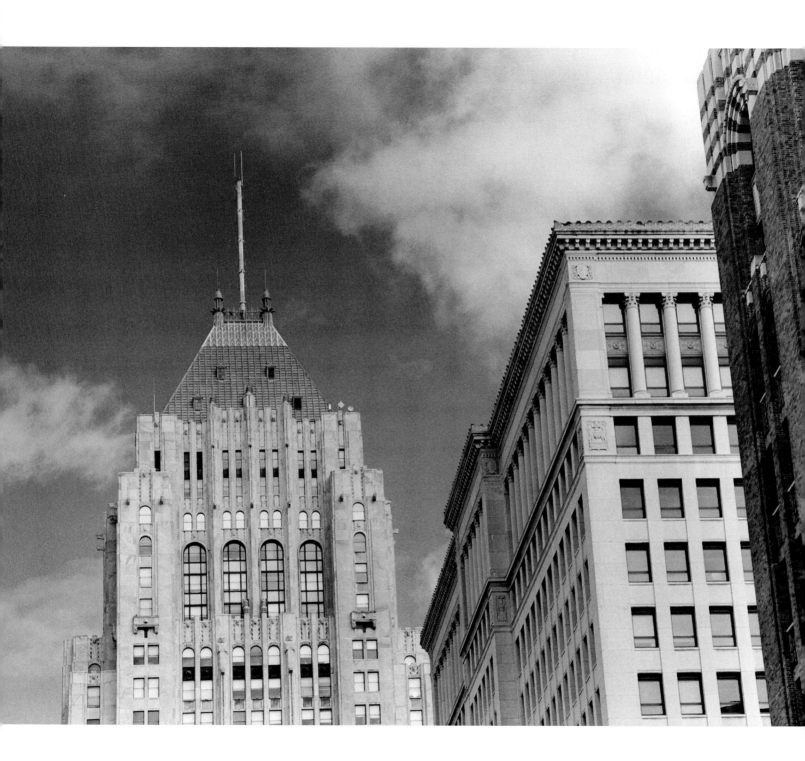

THE FISHER BUILDING

THE FISHER IS A JUNIOR EMPIRE STATE BUILDING SOARING in fluted Art Deco splendor from a parapeted base, Albert Kahn's bold reply to the glass boxes that would eventually smother his art. Three stories of marbled arcade run the length of its base, with room down the center to display everything from antique cars standing on spotless rubber inside velvet ropes to the history of fashion from goatskin to chinchilla wraps.

Lady Yesterday (1987)

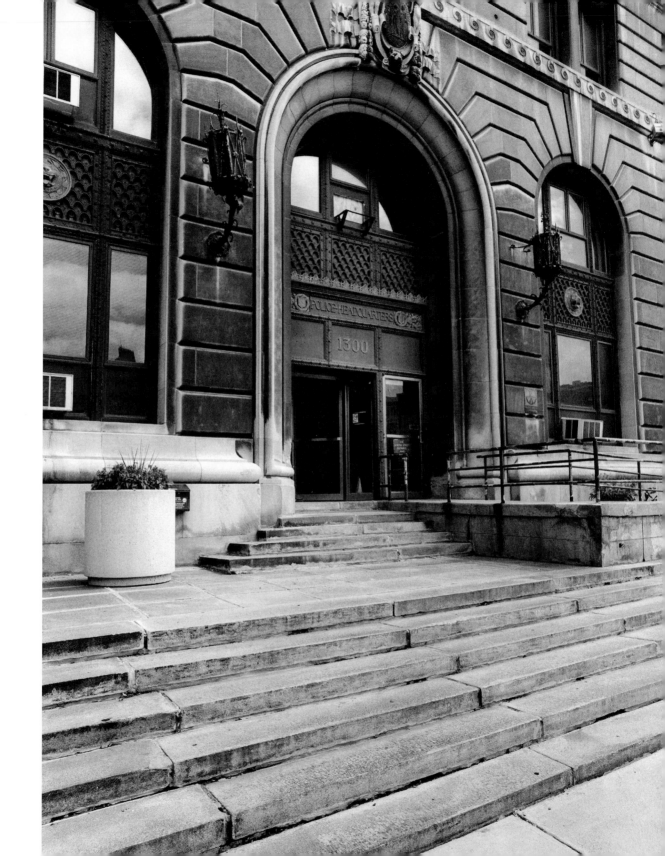

DETROIT POLICE HEADQUARTERS

DETROIT'S CENTER OF LAW ENFORCEMENT IS A MAMMOTH BLOCK structure designed by Albert Kahn and erected in 1922 at 1300 Beaubien, a street named after the French belle who is supposed to have warned the commander of Fort Detroit that Pontiac's warriors were planning to smuggle sawed-off muskets into the garrison under their blankets and take over. The story's probably a myth but the building is real enough, severe and orderly looking with arched windows creating a dungeon effect along the ground floor. Just parking across from it made me feel like confessing.

The Midnight Man (1982)

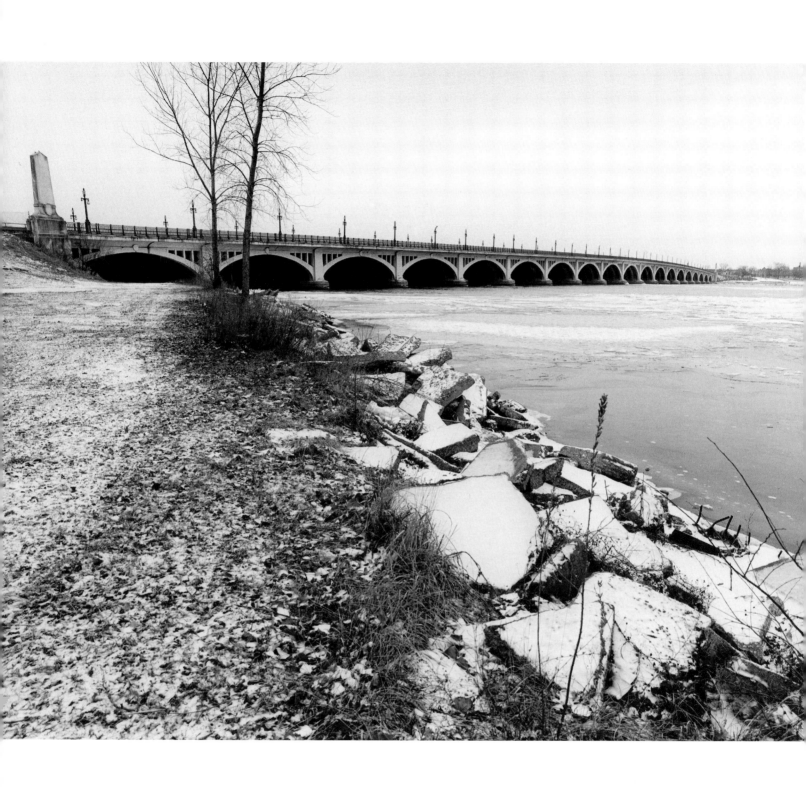

THE BELLE ISLE BRIDGE

THE BELLE ISLE BRIDGE WAS ALL MINE. FARTHER DOWN the river an ore carrier squatted low on the water, but it was something that didn't have anything to do with me or the century I was living in. The snow muffled my tires and the flakes coming down closed in around the car, flowing with it like a communion robe. They landed on the water without a ripple, bobbed once and dissolved. The temperature was just above freezing. By nightfall it would drop and ice would form like candle wax around the banks.

The Hours of the Virgin (1999)

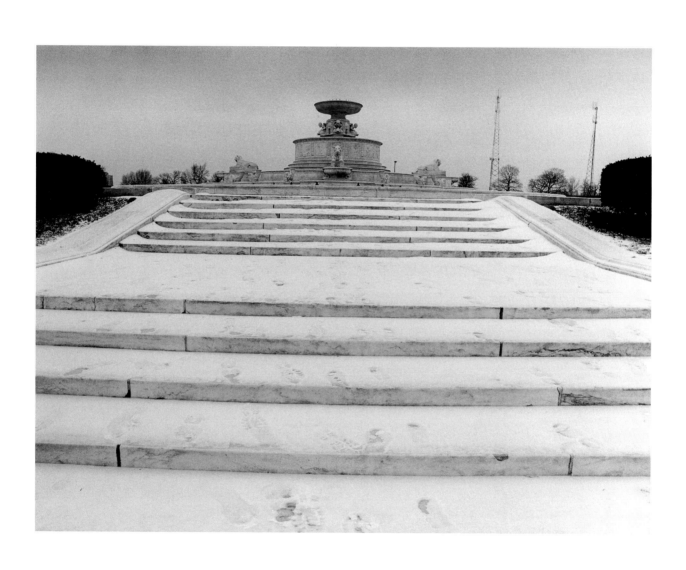

BELLE ISLE

I PARKED IN THE NEAREST LOT, OR WHAT I ASSUMED WAS ONE; the entire island was covered and I couldn't tell grass from asphalt, or for that matter the Scott Fountain from the Dossin Museum. Mine was the only car in sight. I felt like a French explorer.

Like a lot of Detroiters I almost never visit that oblong oasis on the watery border between the United States and the Dominion of Canada. When I do, it always seems to be winter. A few years back I had stood ankle-deep in snow on the softball field and watched three men die. . . .

The Hours of the Virgin (1999)

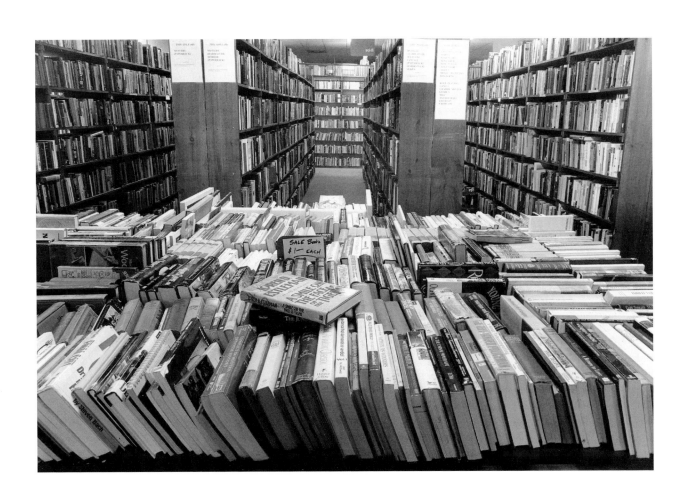

JOHN K. KING BOOKS

THE DRAB FOUR-STORY BUILDING THAT STICKS UP LIKE A
blunt thumb from West Lafayette near the John Lodge Expressway was
moved there when the interstate came through in 1947, God knows why. It's
a hundred years old, but there are holes all over the city skyline where older
and better-looking structures have been pulverized by the wrecking ball. It
had been a glove factory in the thirties and forties, then an empty building
after gloves went the way of Jackie Kennedy's pillbox hat. That was when
John King bought it, tore out most of the partitions, reinforced the interior
walls, and filled it top to bottom with books on every subject, from the wit
and wisdom of Yogi Berra to the post-metamorphal changes in the vertebrae
of the marbled salamander, and by authors as varied as Sinclair Lewis and
Louis Farrakhan. You can smell the decayed paper and moldering buckram
from the far end of the parking lot.

A Smile on the Face of the Tiger (2000)

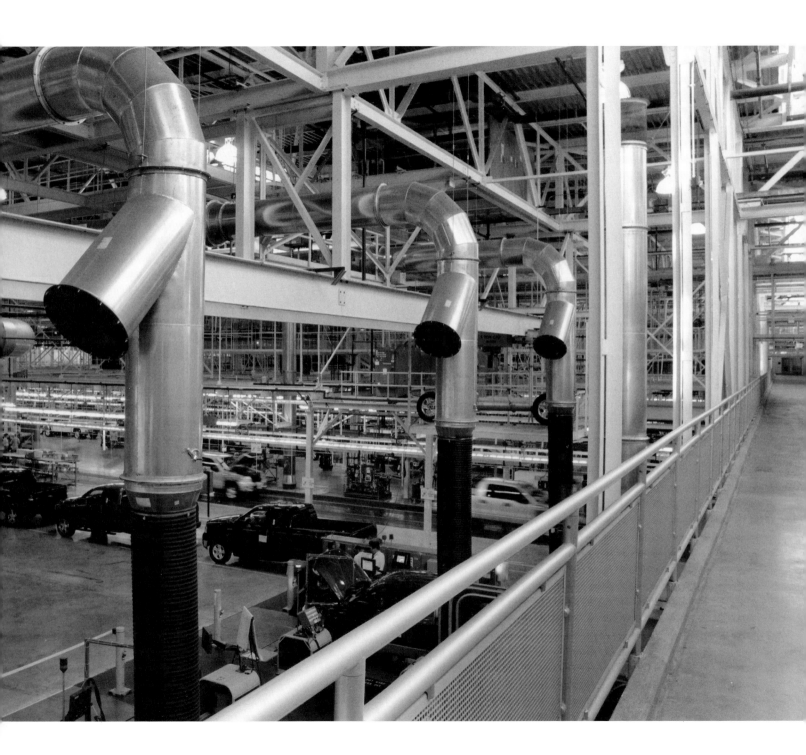

THE FORD RIVER ROUGE PLANT

THE RIVER ROUGE PLANT. HENRY FORD'S SPRAWLING MONUMENT to the Industrial Revolution. One hundred miles of private railroad, a fleet of ships larger than some navies, and enough daily electricity to power two hundred and forty thousand households power its steel mills, coke ovens, glass plant, paper mill, and assembly operation, all in the name of economic parity with Japan. Cadillac and LaSalle camped on this site two centuries before their names fell to the products of Ford's competitors, but they'd have needed more than a map and a sextant to recognize it the day I visited. Dirty pink smoke leaked from stacks, darkened buildings, obscured sluices, and scudded across piles of tailings, the whole gridded by rails as in a tabletop layout, while rust-streaked ore carriers crawled along the scarlet-tinged waterway like bloated sowbugs down a fissure in a wet rock. Pile drivers grunted and clanged rhythmically against the enraged roar of thousands of engines being block-tested. The air was nine-tenths sulfur. It would have been a fine location for a rest home.

The Midnight Man (1982)

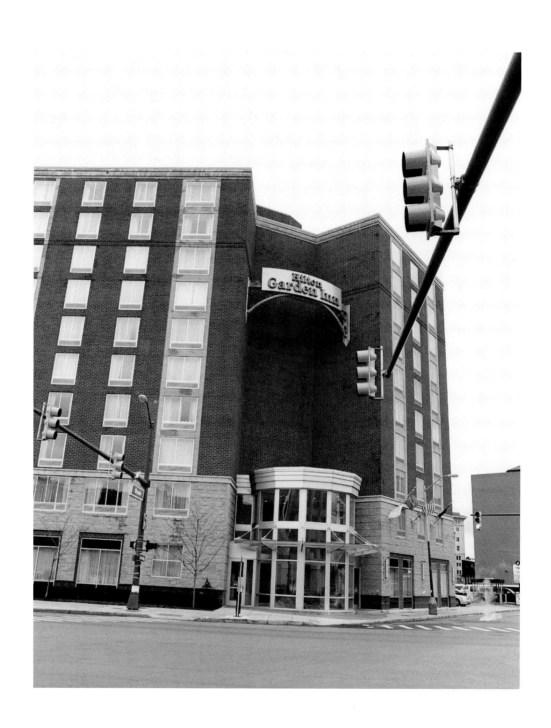

THE HILTON GARDEN INN

DETROIT IS NEVER GOING TO THE SUPER BOWL, SO IT DECIDED to invite the Super Bowl to Detroit. In order to prepare for fans from out of town, the Metro Convention and Visitors Bureau lured in outside investors to build 198 rooms in red brick in the old Harmonie Park neighborhood, close enough to walk to Ford Field—if the game didn't take place in February—and Comerica Park—if anyone cared to see how the Tigers were doing. The Hilton Garden Inn is the first hotel to go up in downtown Detroit since the Atheneum in 1993, but older ones built of better material with more style had been blown up in the meantime.

American Detective (2007)

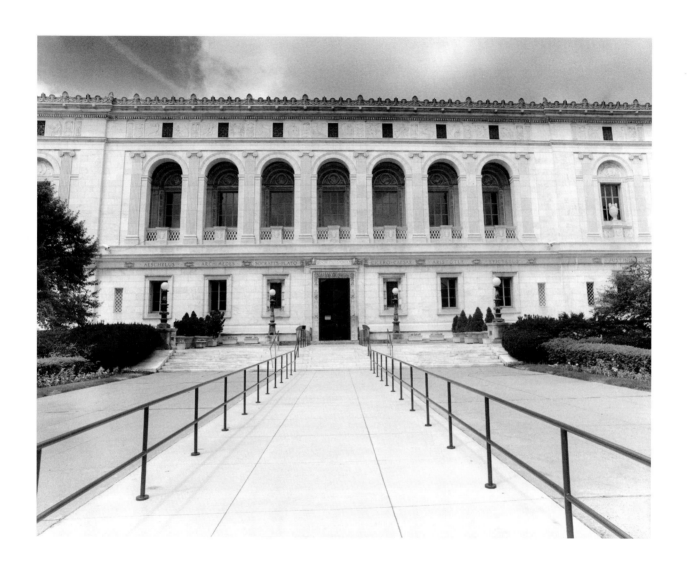

THE DETROIT PUBLIC LIBRARY

Emory Freemantle had been with the Detroit Public Library almost as long as the 1950 Wayne County Manual, and had spent even less time outside its doors. His job was to wear a uniform and wake up the odd bum when he started drooling on Shakespeare's sonnets. I'd been bribing him for ten years to unlock the back door for me midnights and Sundays when I needed to check a fact in one of the newspapers on microfilm.

I parked next to the white marble Main Branch on Woodward and rapped on the fire door. He'd been waiting for me; a key rattled immediately in the lock on the other side, and he swung it open just wide enough for me to slide in around the edge.

"The Woodward Plan" (short story) (2001)

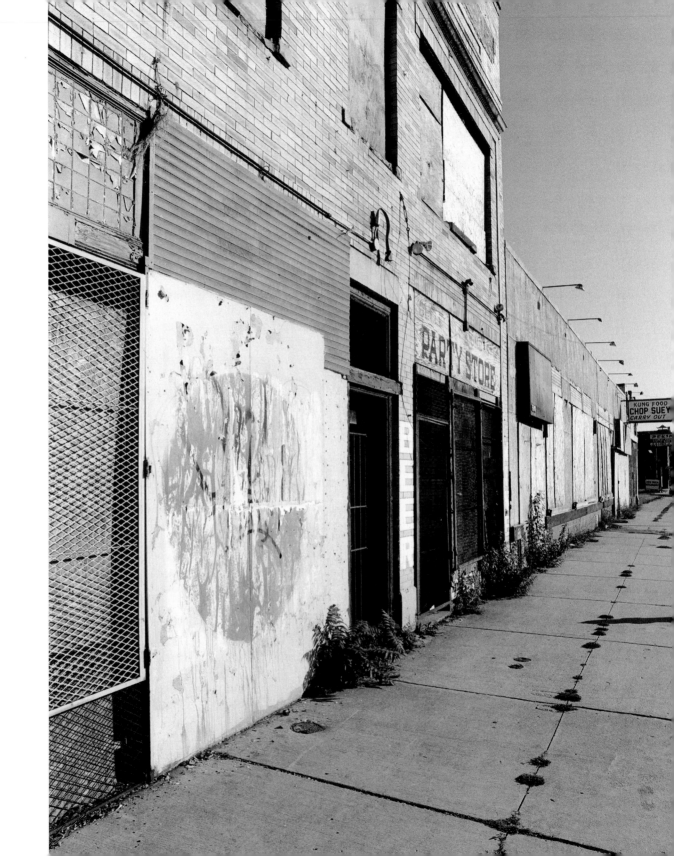

THE CASS CORRIDOR

CASS CORRIDOR. FIRE ALLEY, THE BOYS ON THE DETROIT FIRE Department call it, that neighborhood being the arson capital of the so-called inner city. Most people avoid it even in broad daylight, some from righteous indignation over its thriving hooker trade, others because the Cass Corridor Stranger remains at large five years after the killing ceased. After two in the morning, when the bars and bowling alleys vomit their clientele out onto the street, the area boils briefly, then settles back into sullen dark complacency as it waits to swallow the occasional lone transient. The magic word *Renaissance* opens no doors on Cass.

Angel Eyes (1981)

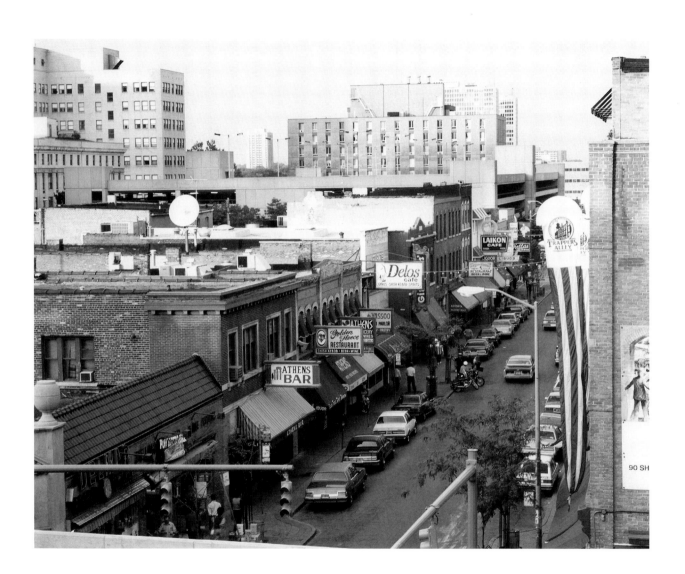

GREEKTOWN RESTAURANT

THE RESTAURANT WAS DAMP AND DIM AND SHOWED EVERY indication of having been hollowed out of a massive stump, with floorboards scoured as white as wood grubs and tall booths separated from the stools at the counter by an aisle just wide enough for skinny waitresses like you never see in Greektown. It was Greektown, and the only waitress in sight looked like a garage door in a uniform. She caught me checking out the booths and trundled my way, turning stools with her left hip as she came.

"Greektown" (short story) (1983)

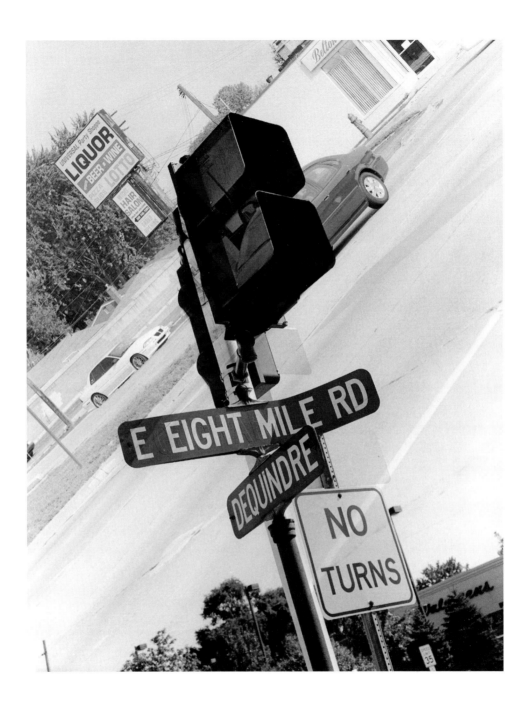

EIGHT MILE AND DEQUINDRE

THE CLIENT WAS A NO-SHOW, AS FOUR OUT OF TEN OF THEM
tend to be. . . . leaving me to drink yellow coffee alone at a linoleum coun-
ter in a gray cinder-block building on Dequindre at Eight Mile Road. . . . A
portable radio was turned to a Pistons game, but the guy who'd poured my
coffee, lean and young with butch-cut red hair and a white apron, didn't look
to be listening to it, whistling while he chalked new prices on the blackboard
menu on the wall next to the cash register. Well, it was March and the Pistons
were where they usually were in the standings at that time and nobody in
Detroit was listening. I asked him what the chicken on a roll was like.

"Better than across the street," he said, wiping chalk off his hands onto the
apron.

Across the street was a Shell station. I ordered the chicken anyway. . . .

"Eight Mile and Dequindre" (short story) (1985)

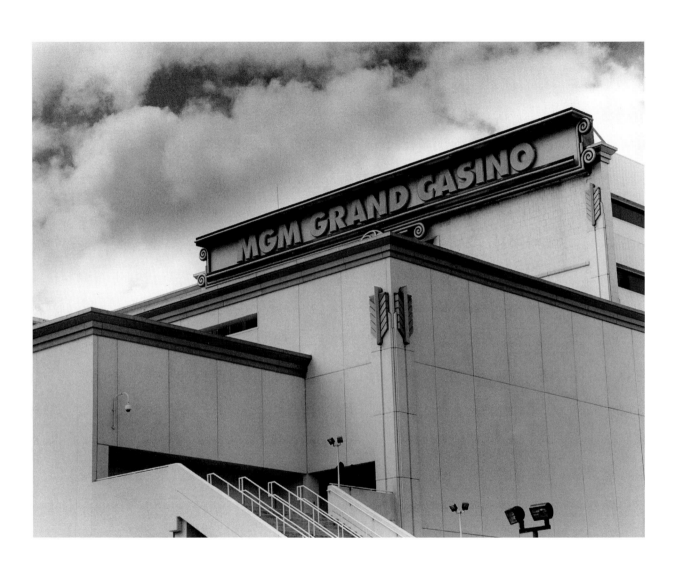

THE MGM GRAND

WHEN SHE LEFT, IN JUST UNDER A MINUTE, I WENT INTO the jangling casino, past banks of senior citizens in pastel sweats working the slots with nothing on their faces but doom, and waited my turn at the roulette wheel. A floor man gave me the fisheye; in January an off-duty cop had shot himself in the Motor City Casino after a bad run of cards, and I must have looked like sad heat. I stepped up and put down the last of what I'd drawn on Rayellen Stutch's check on the black seven at roulette. It was gone faster than Iris.

Sinister Heights (2002)

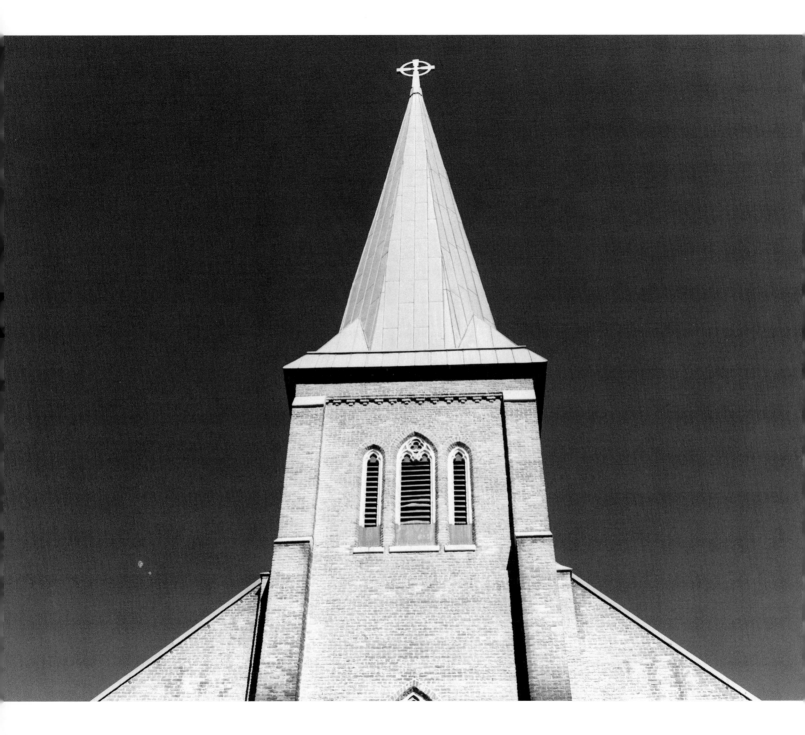

MOST HOLY TRINITY

MOST HOLY TRINITY WAS THE SECOND CATHOLIC PARISH founded in Detroit, a palm for the Irish when they came by the boatload from the potato famine of the 1830s. The present building has been standing nearly one hundred fifty years. . . . Inside the entrance, a bronze plaque depicting an angel and a departing soul in a gondola in relief contains the names of the twelve altar boys and five adults who died when their excursion boat collided with a steamer on the Detroit River in 1880. The pastor, a survivor, called it the Massacre of the Innocents. I took off my hat.

Poison Blonde (2003)

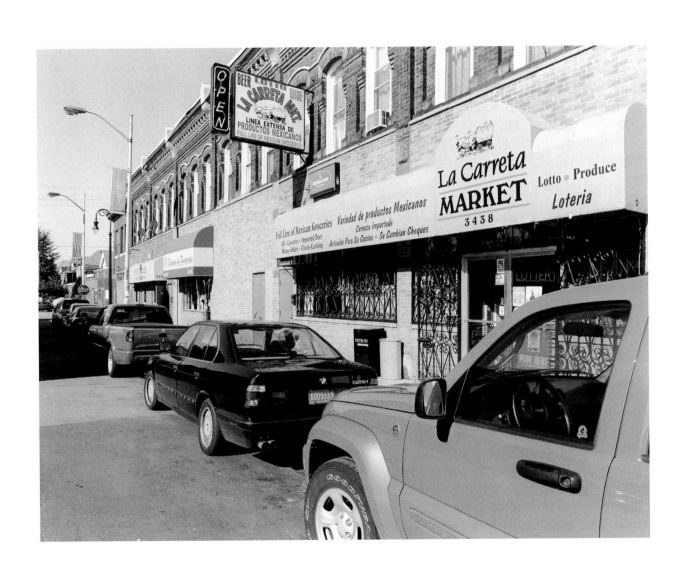

MEXICANTOWN

DELRAY—THE OLD HUNGARIAN SECTION SOUTHWEST OF downtown—had been going steadily Mexican since the 1990s. *Carnicerias* and Mexican restaurants had opened in former pastry shops and Gypsy storefronts, and on Cinco de Mayo the street teemed with pretty *señoritas,* well-kept children in native dress, and mariachis. It was February, and only the Spanish signs and one old woman in a head scarf carrying home a sackful of fresh-slaughtered *pollo* identified the area apart from the many other neighborhoods trying to make the long slow climb from hookshops and crack houses toward lower-middle-class respectability. The current mayor's face smiled out from a ragged poster carrying the legend *Vota Si! por* Detroit.

Poison Blonde (2003)

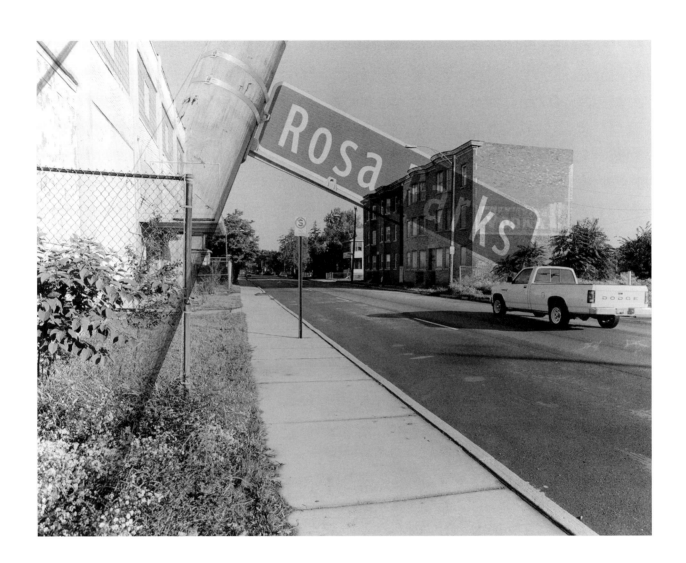

ROSA PARKS BOULEVARD / TWELFTH STREET

BACK WHEN ROSA PARKS BOULEVARD WAS STILL TWELFTH STREET, before the '67 riots, it had sometimes been called Sin Alley, but that was just newspaper talk. Detroiters who were still thirsty when the legitimate bars closed at two knew it as The Strip, a place where a drink or a woman could be had anytime of the day or night. You know it. They might call it the Tenderloin or the Combat Zone in your city, but during an election year or ratings sweeps weeks the local TV stations in towns three thousand miles apart could swap footage and you wouldn't see any difference. You know it by the neon and by Aretha Franklin wailing out of the open windows and by the black girls shivering on the corners in their short skirts and high boots.

Every Brilliant Eye (1986)

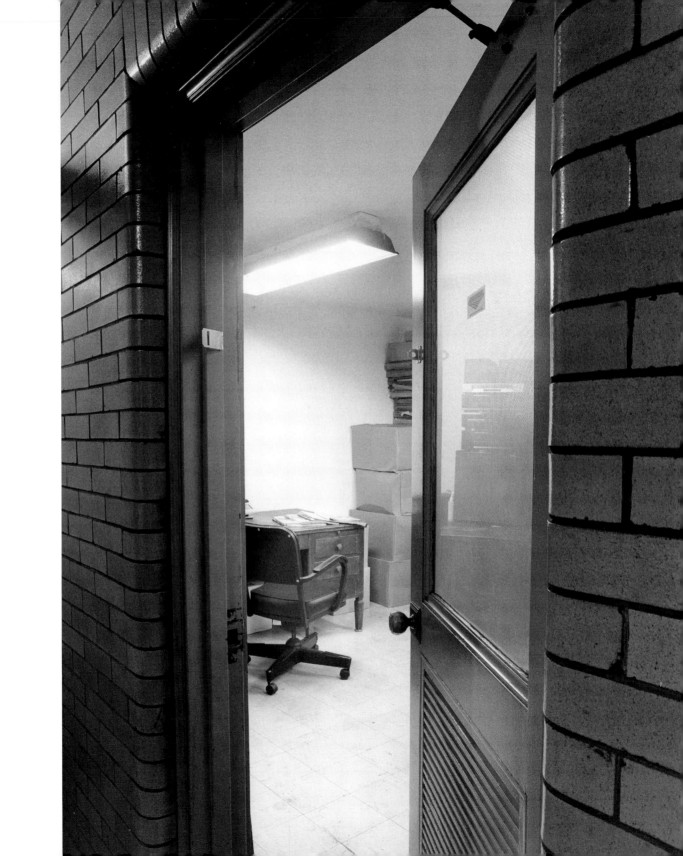

"WALKER'S OFFICE"

MY OFFICE IS A THIRD-FLOOR WHEEZE-UP IN ONE OF THE older buildings on Grand River, a pistol-shot from Woodward. The last time I scrubbed it, the pebbled-glass door, which always reminds me of the window in a public lavatory, read A. WALKER INVESTIGATIONS in flecked black letters tombstoned tastefully across the top and in need of touching up. . . . It's a pleasant enough little burrow, and while the place has never seen a feather duster or broom with bristles stiff enough to reach into the corners, let alone the Silver's Touch, it has everything a PI requires, including a file cabinet with the worst dents shoved up against the wall, a backless sofa suitable for snoozing one off, and a desk with a bottom drawer deep enough to store a bottle of Hiram Walker's upright, suitable for tying one on.

Motor City Blue (1980)

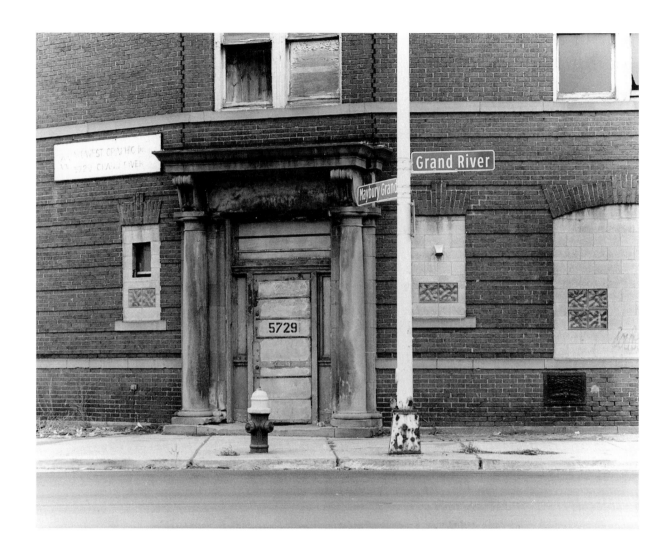

"WALKER'S BUILDING"

It's an old building by local standards. John Brown might have ridden past it in a four-in-hand on the northern spur of the Underground Railroad. In any other city it would be an archaeological treasure, and a slot for it on the National Register would be someone's cause of the month, but in our town it's just another empty lot in waiting. The corporation that owns it budgets just enough to prevent that, paying an old Russian Jew to bang on the radiators and a crew to sweep out the butts and unclog the waterspouts shaped like griffins. I like it because they let you smoke in the offices. You can probably sacrifice a goat if you want to badly enough.

Poison Blonde (2003)

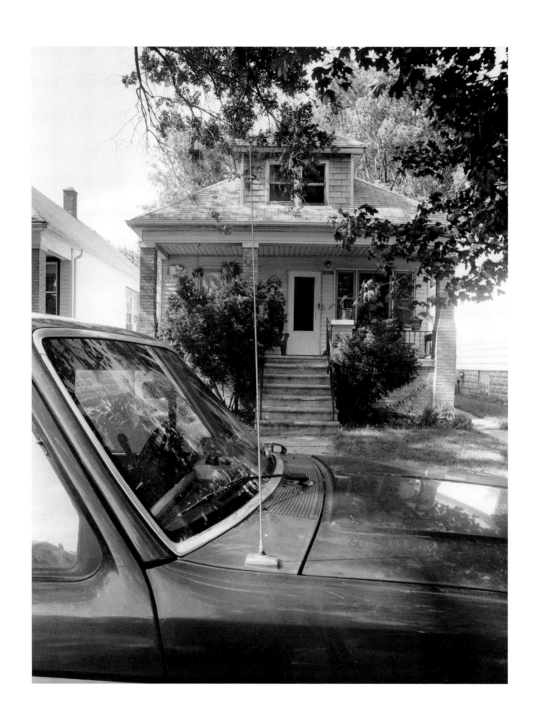

"WALKER'S HOUSE"

IT'S EIGHT HUNDRED SQUARE FEET ON THE BORDER OF Hamtramck and the United States, too small for a house and not quaint enough for a cottage. I acquired it from a foreman at Dodge Main who'd bought it for a starter home in 1940 and moved out thirty years later into his daughter's house after she caught him trying to replace a spent fuse with a shotgun shell. After twenty-five years I don't guess it's a starter for me either. It's a place to smoke a cigarette without alerting Detroit Vice, and maybe the only place in the solar system where a man can tell a visitor to go screw himself and make it stick. It needs a new roof, a coat of paint, and while we're at it a cellar stocked with vintage Amontillado, excellent before dinner and when entombing enemies. I'd settle for the paint.

Poison Blonde (2003)

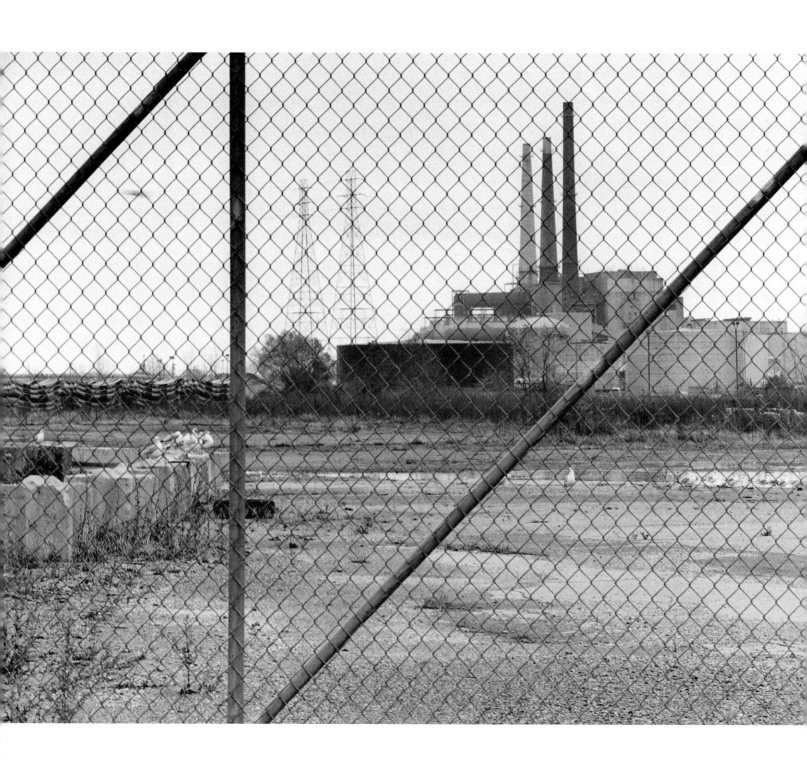

"THE STUTCH MOTORS PLANT"

THE STUTCH MOTORS PLANT CROUCHED ON ITS HILL LIKE a gaunt spider, casting no shadow under a clouded noonday sky, vampiric. Even the smoke from its three stacks didn't appear to be moving, parallel rivulets dried to black crusts on zinc. The gridded window on this side reflected the buildings of Iroquois Heights. It wasn't giving up anything.

Sinister Heights (2002)

"THE TOMCAT THEATRE"

THE TOMCAT THEATRE WAS ONE OF THOSE HISTORICAL RELICS no one would miss when they finally went the way of all brick. Fifteen years ago it had been one of a hundred places around town where a lonely man in a raincoat could go when all the impressionable young ladies were unavailable for flashing; those throbbing hot-pink wombs smelling of bleach and mildewed plush and chewed spearmint, lit chiefly by the dusty beams of out-of-date projectors and the grainy flesh onscreen. The erosion of city fines, committees of decency, and—most important—stiff competition from chain video stores had ground them down to this one cinder-block building, painted celery green and set back from Telegraph Road under a stuttering marquee whose weight seemed to be pressing the structure into its own foundation. . . . The advertised feature was *Psycho Night Nurses in Chains,* or some shopping list of appropriately prurient nouns and adjectives like that. The bottom half of the double bill, *Horny and the Bandit,* was in the eighteenth year of a three-week run.

The Hours of the Virgin (1999)

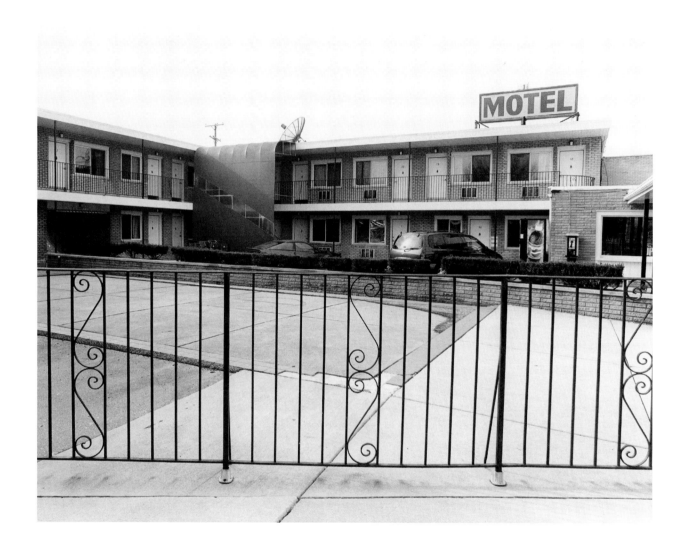

"THE ALAMO MOTEL"

THE ALAMO MADE A GOOD CASE FOR BEING FORGOTTEN. The name was etched in sputtering orange neon across a plate-glass window with the shade pulled halfway down like a junkie's eyelid and the front door, a thick paneled oak job that had been refinished under Truman, stuck in its casing and required a shoulder to open. Inside, a green brass lamp with a crooked paper shade oozed light onto a waist-high counter with a floor register in front of it to catch coins. . . . On the wall behind the counter, next to a life-size acrylic painting on black velvet of John Wayne dressed as Davy Crockett, a sign was tacked reading:

THE ALAMO HOTEL
(Permanents and Transients)
No Pet's
No Children
No visitor's in Rooms
No TV or Radio after 10:00 PM
Enjoy Your Stay

Downriver (1988)

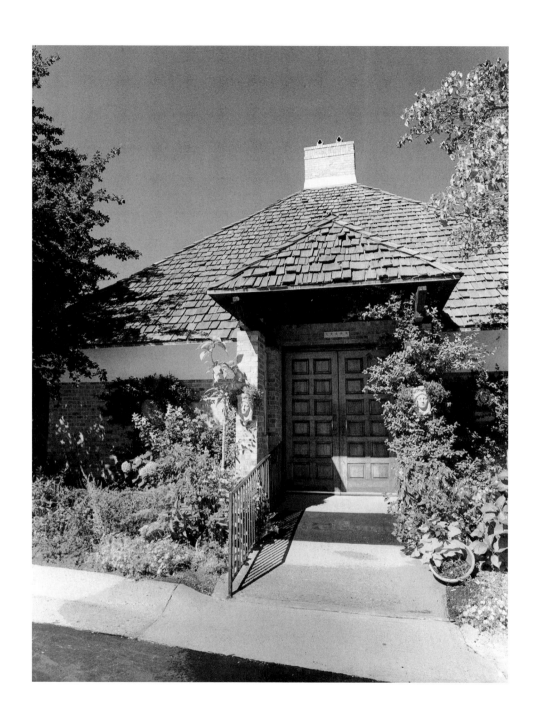

"THE BLUE HERON" (THE LARK)

THE BLUE HERON OCCUPIED A SMALL BUILDING OFF ORCHARD Lake Road, built of orange brick with vines growing up the outside and young men in blue blazers stationed out front who soaked you a buck to move your car ten feet and leave it. A blonde hostess in blue taffeta and a scarlet bustier smiled at me coolly and led me to a booth in the back, one of those awkward arrangements where you and your companion sat hip to hip and reacted out of the sides of your faces like cons in an exercise yard.

Silent Thunder (1989)

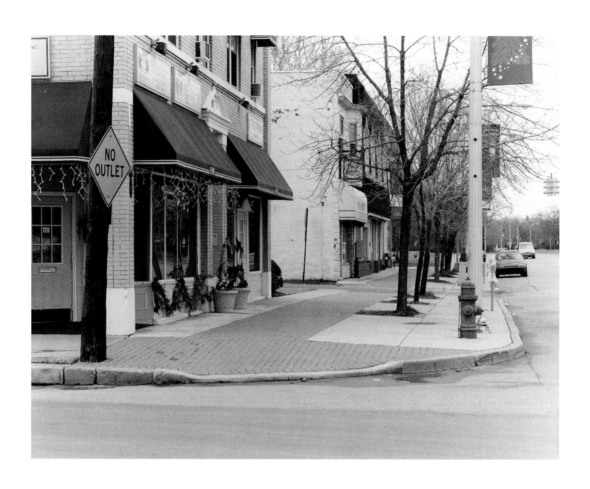

"IROQUOIS HEIGHTS"

IROQUOIS HEIGHTS WAS THE KIND OF PLACE THAT YOU wanted to live in if you were in the 40 percent bracket and you didn't care which pies your local public servants had their fingers in so long as they kept their campaign volunteers off your doorstep and the neighbor's junkie kid away from your stereo. It was one of those jut-jawed little communities that advertised on television warning lawbreakers to steer clear of the city, and at election time they put teeth in it by raiding some giggle parlor or other that was casting too big a shadow. There was a newspaper, but it was part of a chain belonging to a sometime political hopeful and its editors had stiff necks from looking the other way. The streets were clean, the homes were kept up, and every block had a young oak growing out of a box on the sidewalk. From the mayor to the cop on the corner, you could buy the whole place for pocket change.

The Glass Highway (1983)

DEARBORN

DEARBORN IS FORD COUNTRY, BUILT FROM THE AXLES UP by the same people who gave us the Model T and the modern American labor movement. The local Ozymandias is everywhere represented: in its school, its medical facilities, its public institutions, and its street names. Henry Ford Museum, Henry Ford Community College, Henry Ford Hospital, and the Ford Motor Company's global headquarters are all there, a piston-rod's throw from Ford Road and the Edsel Ford Freeway. The old crab's angular figure stands in bronze, marble, granite, and cream cheese throughout the city, and with excellent reason. If not for him the place would still be a farm village, the mighty River Rouge plant a mosquito-infested swamp, and the whole not worth the effort of collecting taxes.

Retro (2004)

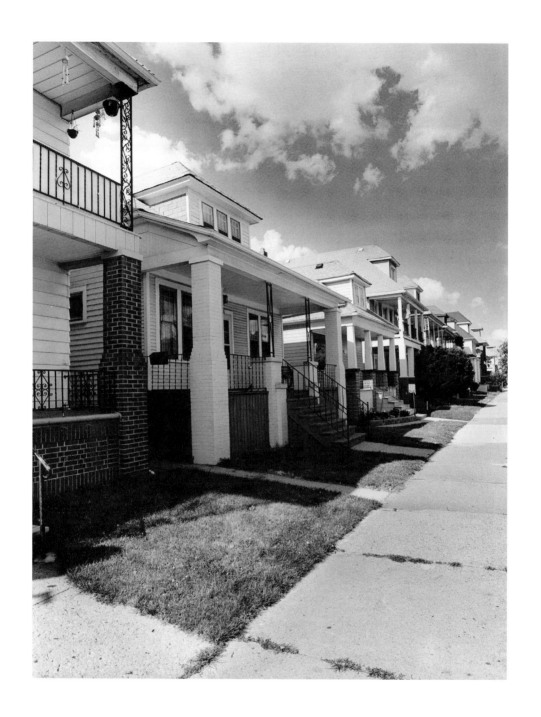

HAMTRAMCK

There is nothing spiritual about Detroit's Poles. They are the supreme property owners of the Western Hemisphere. . . . Hamtramck to this day boasts the highest percentage of home ownership of any city in the country.

Driving down Chene through the old village with its tight rows of identical century-old houses painted in peeling colors, you still catch glimpses of the melting pot: old men loitering in front of the old Round Bar where as children they had packed the balcony along with their fathers to watch the struggling, glistening naked backs of the wrestlers below; a thick-ankled housewife slitting a duck's throat in her backyard and holding it flapping upside down while her little daughter catches the warm blood in a bowl for the soup they call *czarnina;* native costumes sagging from the pulley-operated line waiting for the Polish Constitution celebration on Belle Isle. But you have to look quick, because it's going, going to eminent domain and General Motors' golden ring in the nose of City Hall, its churches knocked to rubble and kindling, the bricks that paved its medieval alleys piled in heaps for the scavengers.

Sugartown (1984)

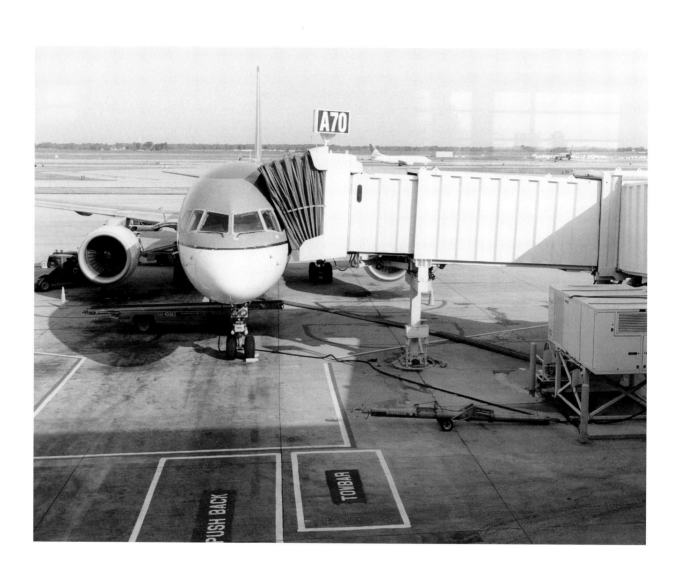

DETROIT METROPOLITAN AIRPORT

A FUEL-GUZZLING JET VENERABLE ENOUGH TO HAVE STARRED in Chet Huntley's coach lounge commercial in 1972 bellied in over the tarmac, touched down with a shriek of rubber, and taxied toward the gates with beads of rain glittering like perspiration on its red-and-white metal skin. The sky had been weeping over the metropolitan area since before dawn, lowering the temperature another ten degrees and putting paid to the hot spell, at least until the next front came through or the fan in my office gave up the ghost. Burning cigarettes with the rest of the lepers in the designated area, I rested my feet on my overnight bag and hoped for a craft built sometime in the present decade. Flying is one of those activities best left to children and that class of adults who are content to let other people make decisions regarding their survival, like Szechuan chefs.

The Witchfinder (1998)

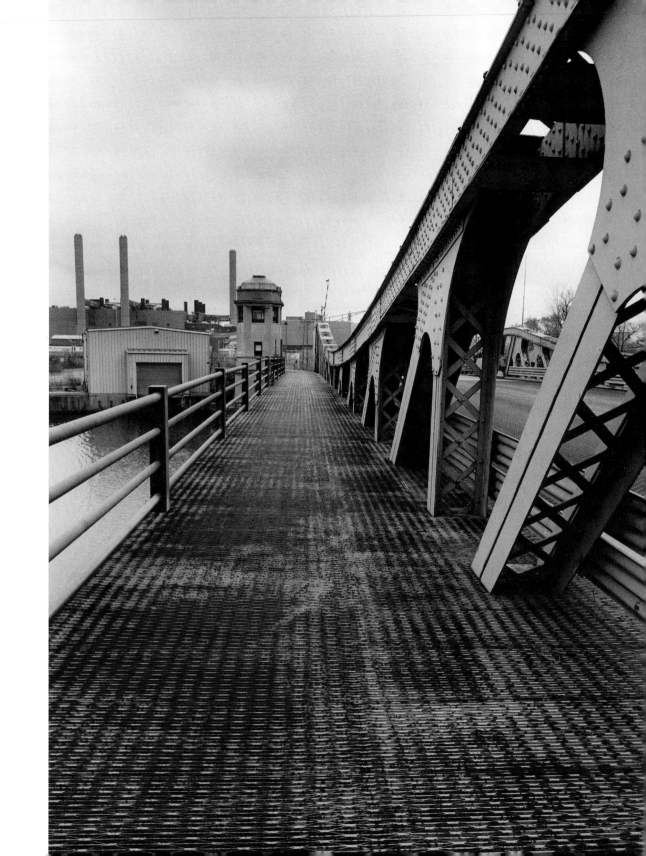

ECORSE

THE DAY WAS WELL ALONG WHEN ALDERDYCE AND I SHARED the Ecorse dock with a crowd of local cops and the curious, watching a rusty sedan rise from the river at the end of a cable attached to a derrick on the pier. Streaming water, the glistening hulk swung in a wide, slow arc and descended to a cleared section of dock. The crane's motor died. Water hissed down the archaic vehicle's boiler-shaped cowl and puddled around the rotted tires.

"Robbers' Roost" (short story) (1982)

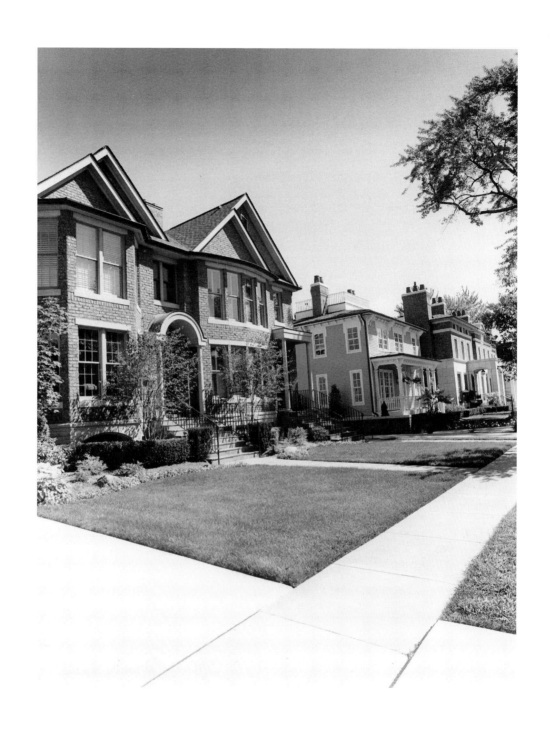

BIRMINGHAM

Birmingham started expanding after the last big war as the waiting room for Grosse Pointe, a place where new money was left to mellow and season in brick split-levels before moving into the great Prohibition-era mausoleums on Lake Shore Drive.

Silent Thunder (1989)

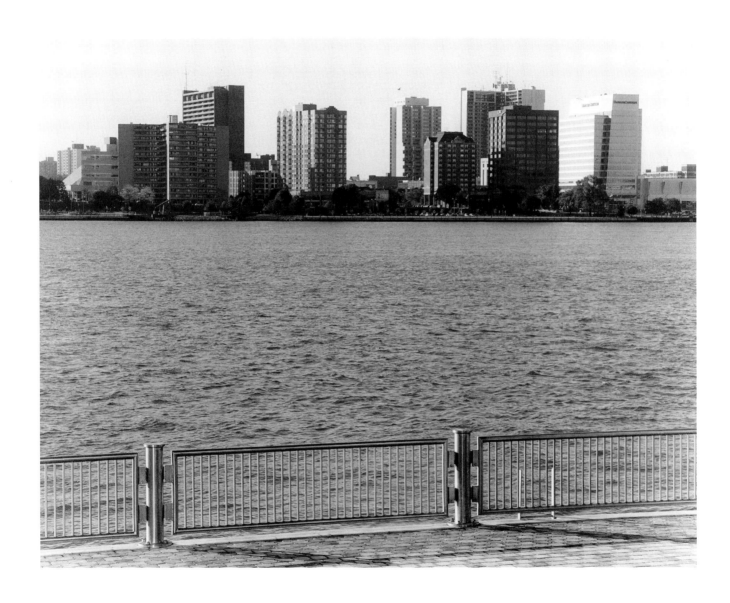

WINDSOR

Windsor is just Detroit after the maid's been in.

The Glass Highway (1983)

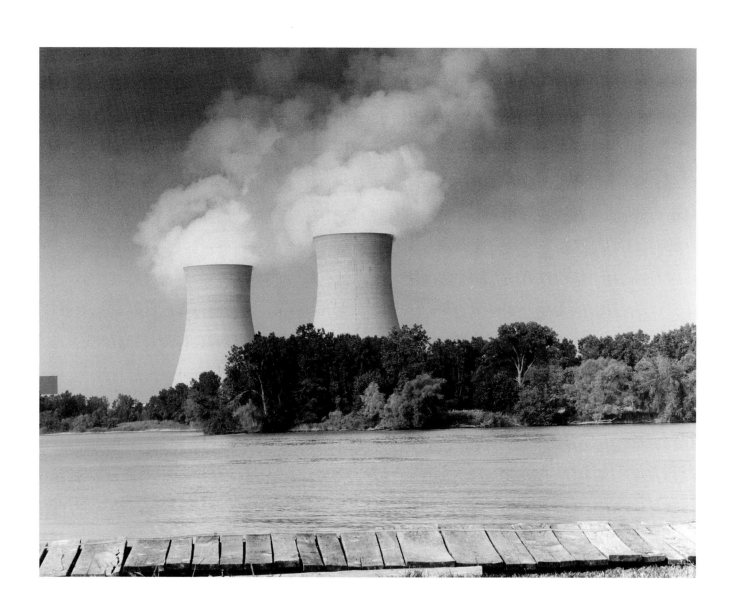

MONROE

Dusk was gathering as I entered the city of Monroe, but the streets weren't glowing, a positive sign. A near-meltdown at Enrico Fermi, the world's first nuclear energy plant, at nearby Lagoona Beach came within atoms of wiping out southeastern Michigan in 1966, along with part of Ohio and the entire fishing industry on Lake Erie. The plant closed soon after, but cloned itself into Fermi II, and a generation of Monrovians had come to their majority uncertain about how much time they had before the next—and last—incident. Pedestrians walk the small-town streets with a cringing gait, the way West Berliners used to when they entered the shadow of the Wall.

Sinister Heights (2002)

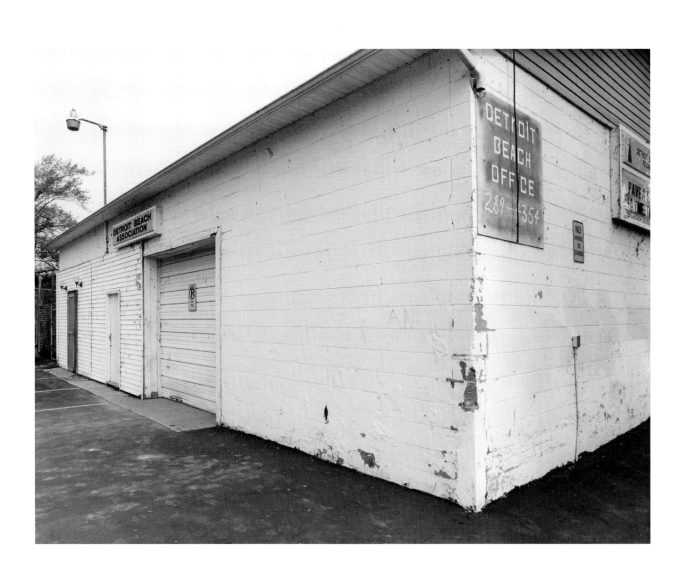

DETROIT BEACH

MOST DETROITERS HAVE NEVER HEARD OF DETROIT BEACH, a quiet little sun-faded community where gulls and sun-worshippers go to avoid the crowd on Belle Isle and at Port Huron. Few of them know that they owe the spot to the pioneers who chopped down trees four generations ago to land high-powered boats loaded to the gunnels with whiskey smuggled from Canada; by then the Detroit riverfront was filled with U.S. Coast Guardsmen with their hands out, and nearby Monroe with rival machine-gunners. The balmy days of Michigan are few, and bright umbrellas tend to sprout on every bloody patch of shore.

American Detective (2007)

WESTLAND

Westland is a workingman's community, functional if it's nothing else, and nothing else is exactly what it is. No restaurants of note, liquor stores with iron bars that fold over the windows at closing, pool tables and shuffleboard games in bars where the customers wear Hawaiian shirts and knock back boilermakers and play Waylon Jennings and Merle Haggard on the jukeboxes. Bleak streets lined with bleak houses spreading out from the General Motors assembly plant, making a town as flat and gray as a concrete slab. . . . In that season it looked like the kind of place where laid-off line workers massacre their whole families and then shoot themselves.

Lady Yesterday (1987)

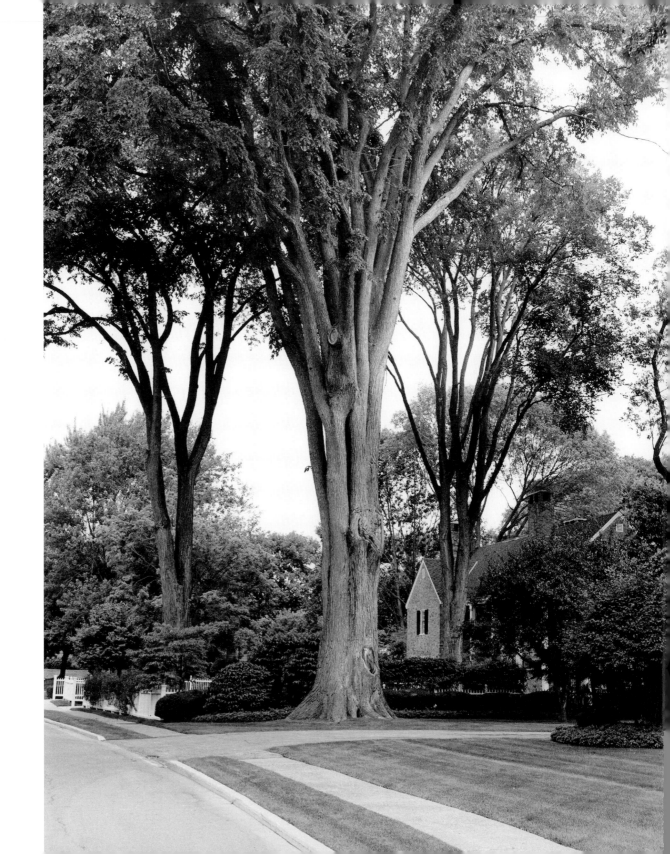

GROSSE POINTE

Whoever said all men are created equal must have had his eye on a home in Grosse Pointe. In this democracy, anybody can hope to grow up and live in the riverfront suburb, provided his credit rating is A-1 and he's prepared to mortgage himself to the eyes. Something over a hundred years ago, a healthy chunk of the area to the west was under the control of Billy Boushaw, boss of the First Precinct of the First Ward, whose old saloon and sailors' flophouse stood at the northwest corner of Beaubien and Atwater streets, but that's a slice of history they don't serve in the local schools. Now, it's rich town, and the best-patroled square mile in the city. On maps it usually appears in green.

Motor City Blue (1980)

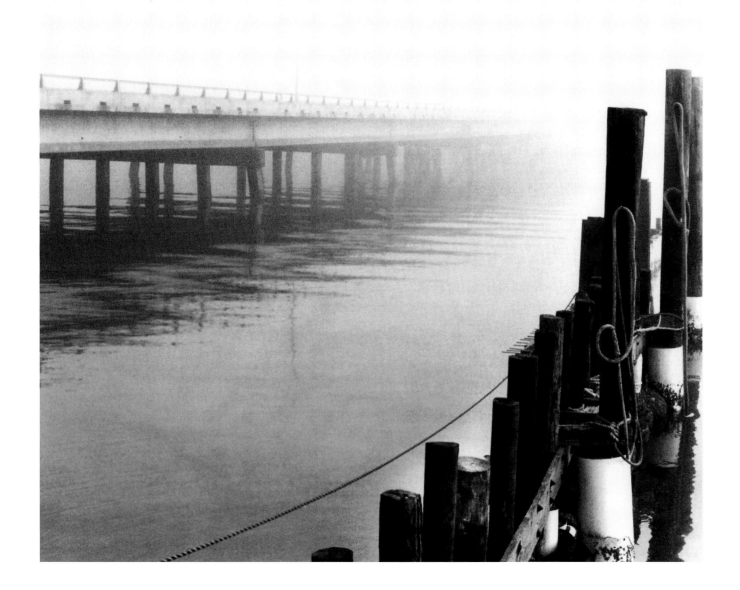

PORT HURON

WHEN THE LOGGING BUSINESS RAN OUT OF TREES UNDER President Cleveland, the sawmills shut down, and with them the railroads connecting them to Flint, Saginaw, and Ludington, clear across the state on Lake Michigan. Port Huron sold pencils for a while from a tin cup. When the foundries in Detroit couldn't keep up with the production lines at Ford and General Motors, steelmaking plants sprang up on the mouth of the St. Clair River where Lake Huron emptied into Lake St. Clair. Then miles of white beach opened for business, and for a little while, until the black flies came and the superhighway system discovered Miami, the place was a little northern Riviera three months out of the year, complete with freshwater clam restaurants propped up on piers and *Rhapsody in Blue* drifting out from a band shell. On a hot Sunday in July or August, striped umbrellas still crowd the shoreline, and the sails of the Port Huron-to-Mackinac Race blot out the blue water in midsummer, but most of the time it's the sanitation crews shoveling up dead fish and old condoms who get the best tans. On the first iron-scraped workday of the year, the place was Moscow, with a view of Ontario.

Nicotine Kiss (2006)

CREDITS

The following novels were first published by Houghton Mifflin, Boston:

Motor City Blue
Angel Eyes
The Midnight Man
The Glass Highway
Sugartown
Every Brilliant Eye
Lady Yesterday
Silent Thunder
Downriver
Sweet Women Lie

The following novels were first published by Mysterious Press/Warner Books, New York:

Never Street
The Witchfinder
The Hours of the Virgin
A Smile on the Face of the Tiger
Sinister Heights

The following novels were first published by Forge Books, New York:

Poison Blonde
Retro
Nicotine Kiss
American Detective

The following short stories first appeared in *Alfred Hitchcock's Mystery Magazine,* Davis Publications, New York:

"Greektown"
"Eight Mile and Dequindre"